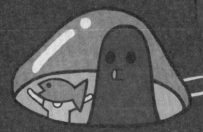

TAKO KNOWS

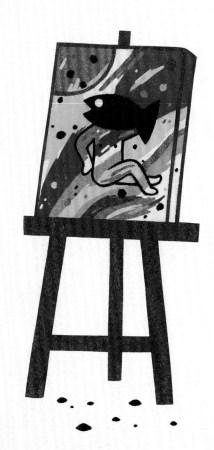

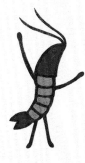

NAOSHI

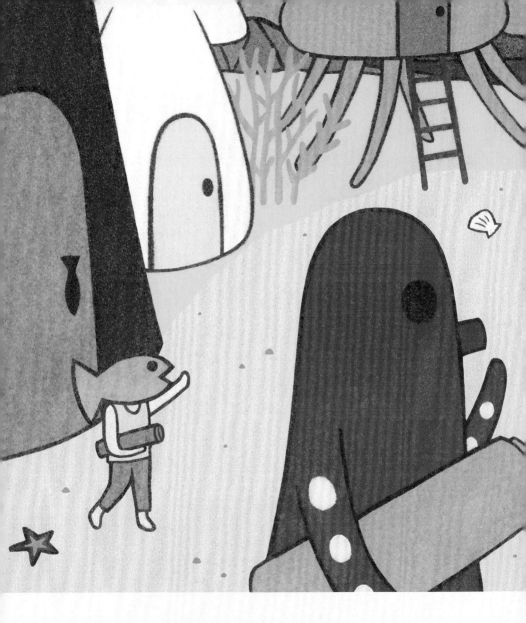

Hello! I'm Tako.

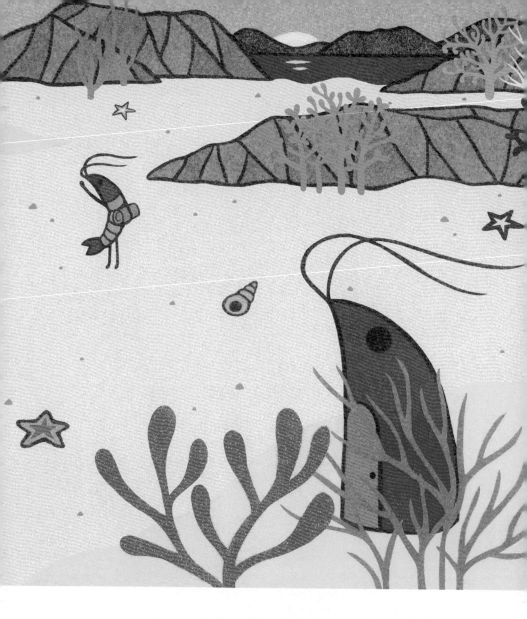

A day in Tako City begins with the sunrise.

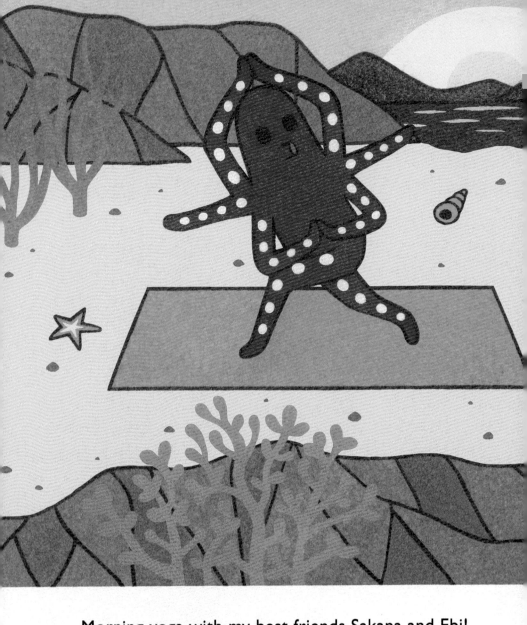

Morning yoga with my best friends Sakana and Ebi!

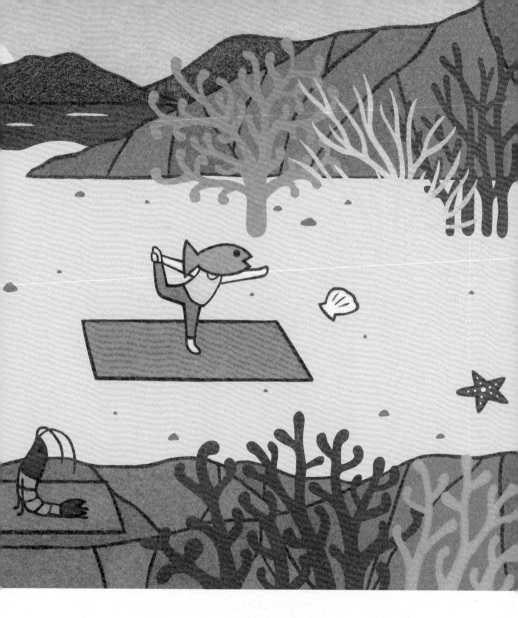

We prepare our mind and body to start the day.

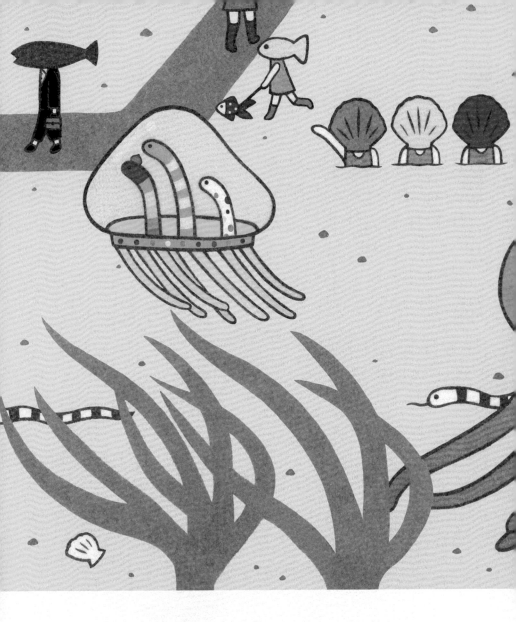

Cheerfully off to work in the jelly-mobile!

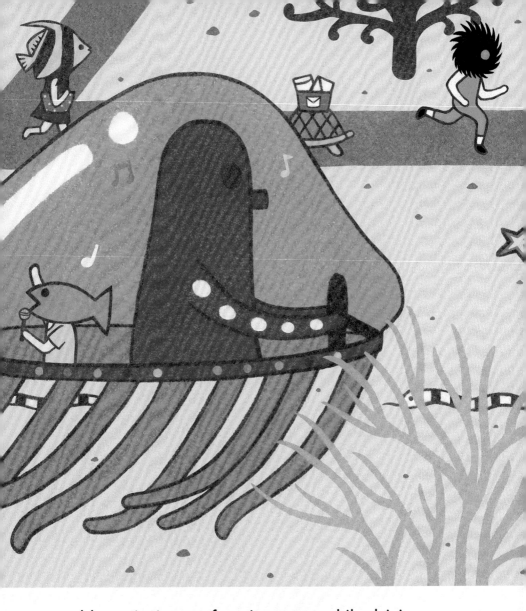

I love singing my favorite songs while driving.
Sakana always sings along with me.

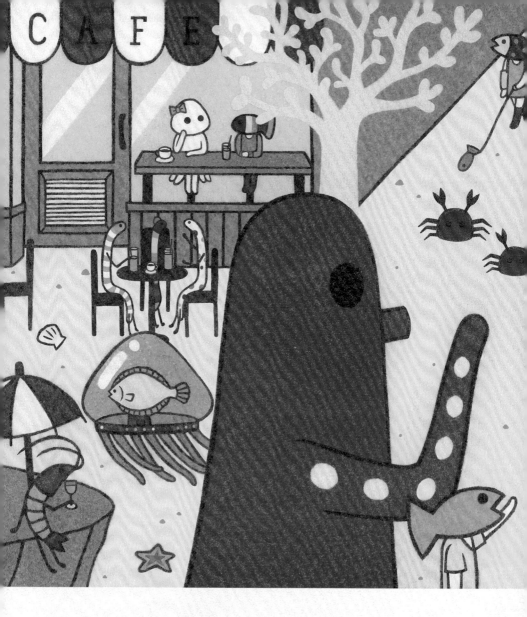

Good morning, Ika!

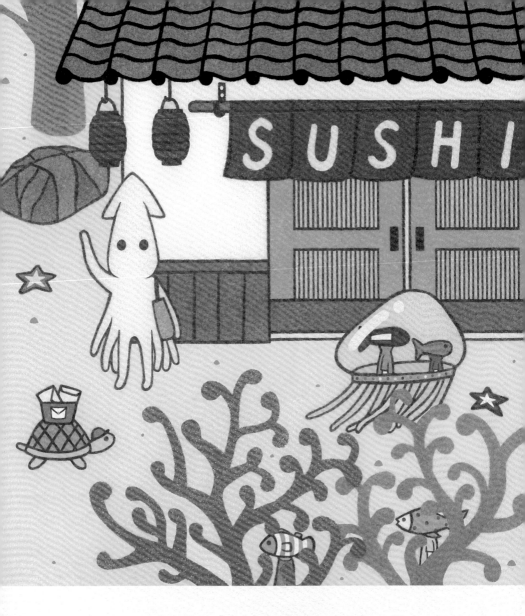

She's a very thoughtful colleague.

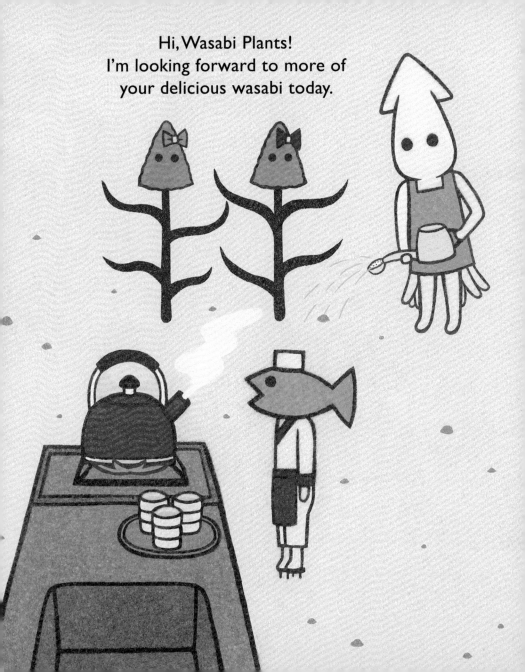

Let's work hard and make our customers smile!

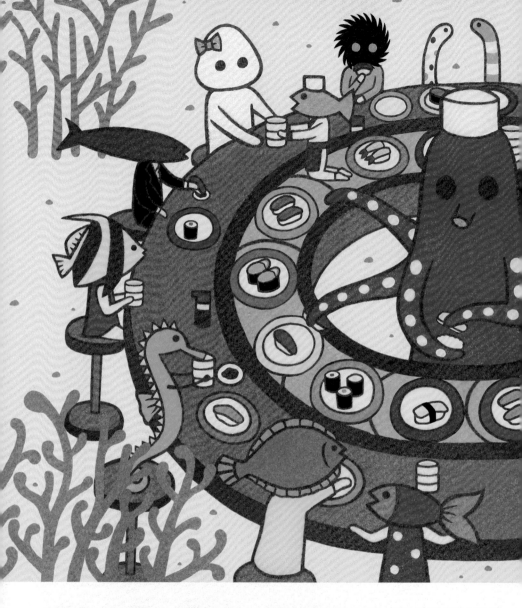

TAKO, THE SUSHI CHEF!

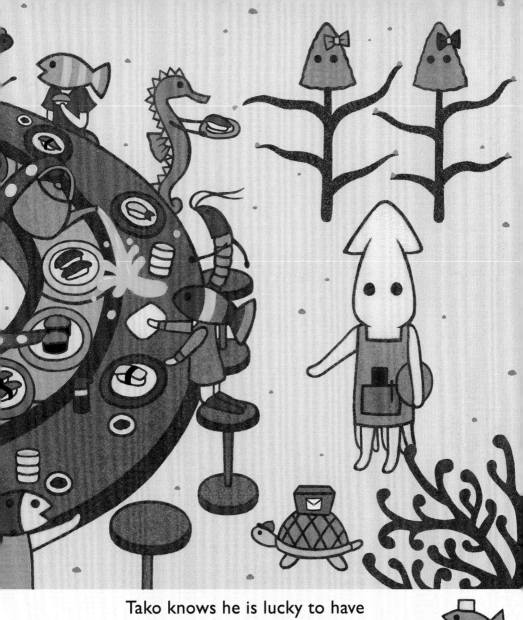

Tako knows he is lucky to have
a fulfilling job and close friends.
But Tako doesn't know he's spilling the tea.

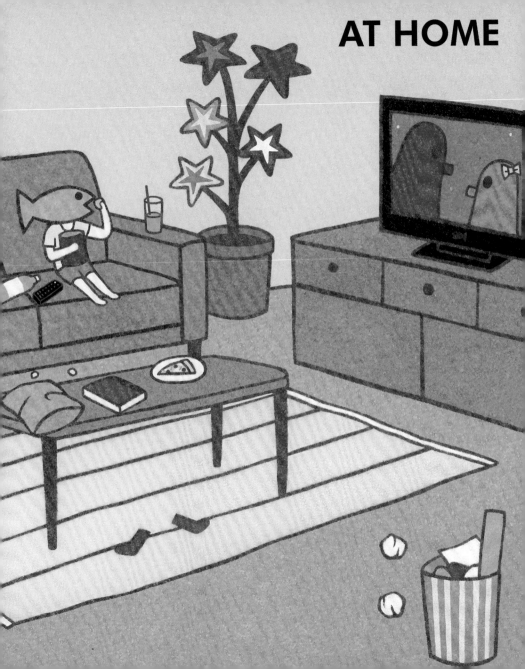

I can't relax in a messy room.
Hi, Smiley Flowers!
We'll change your water.

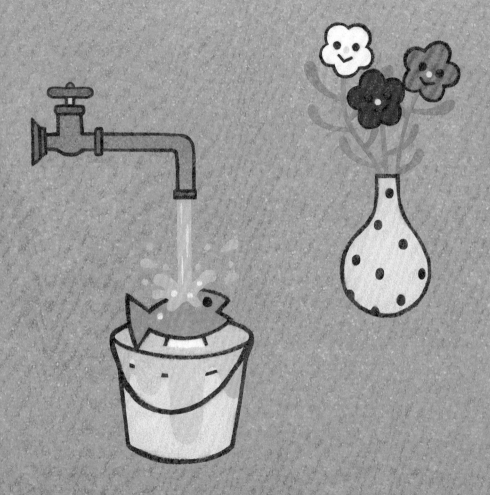

Let's clean up together, Sakana!

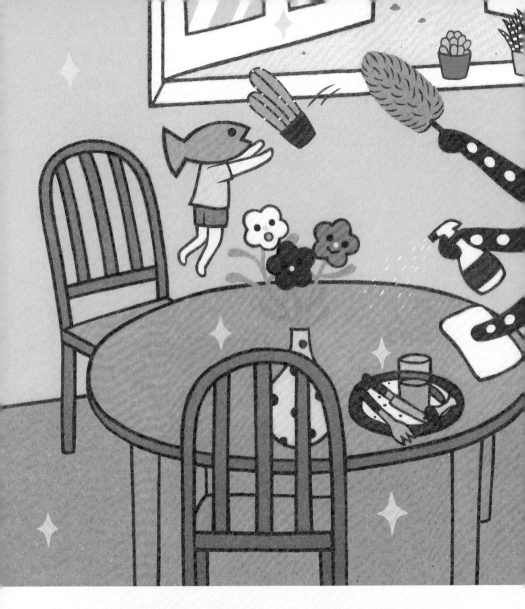

TAKO, TIDY ROOMIE!

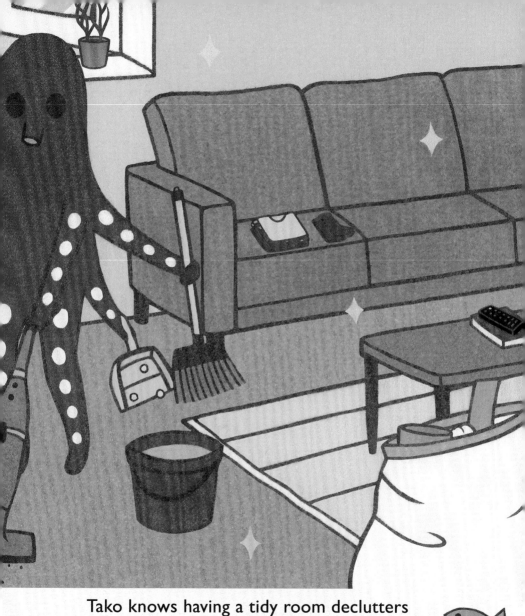

Tako knows having a tidy room declutters
his mind and gives him a sense of fulfillment.
But Tako doesn't know he's knocked the plants over.

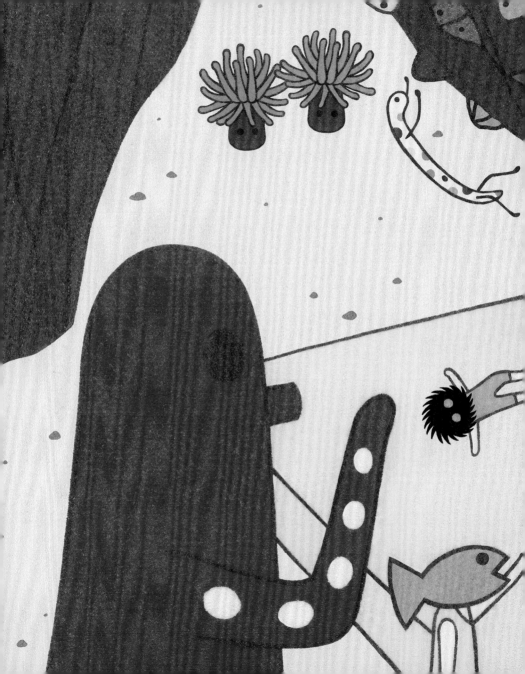

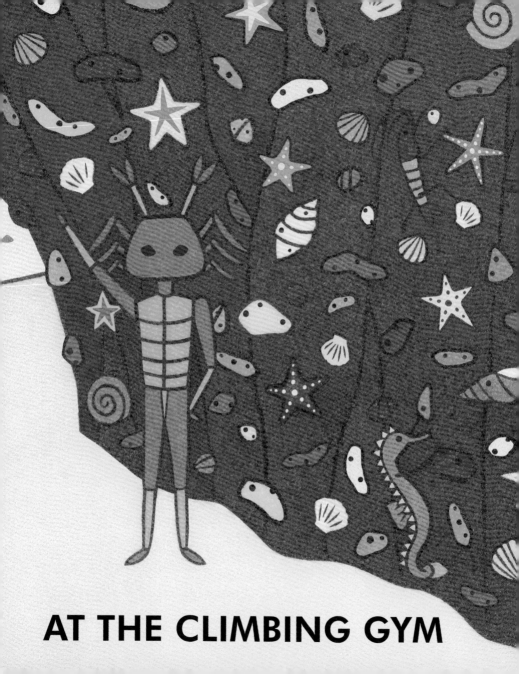

AT THE CLIMBING GYM

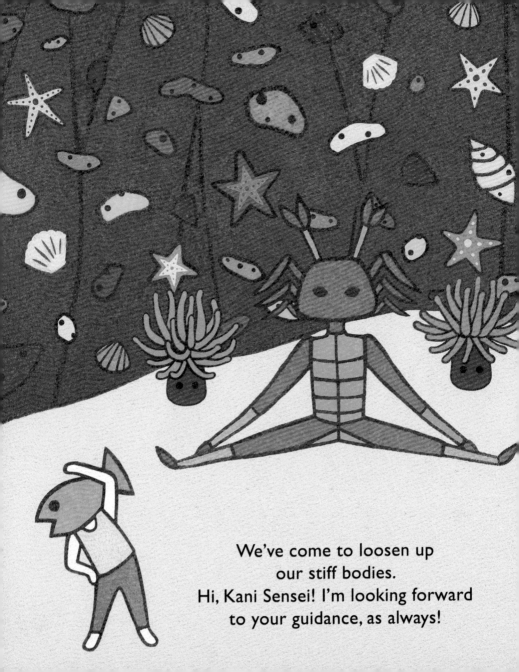

We've come to loosen up
our stiff bodies.
Hi, Kani Sensei! I'm looking forward
to your guidance, as always!

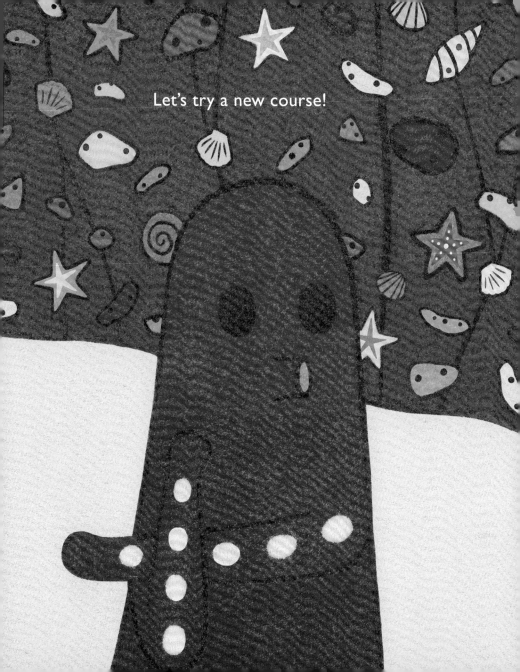

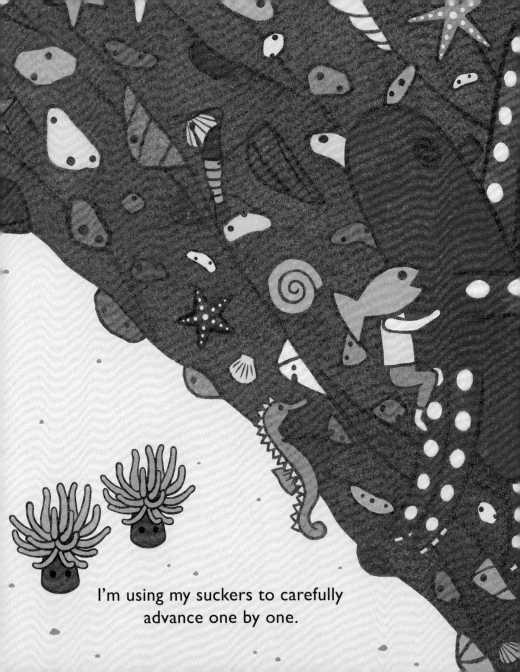

I'm using my suckers to carefully
advance one by one.

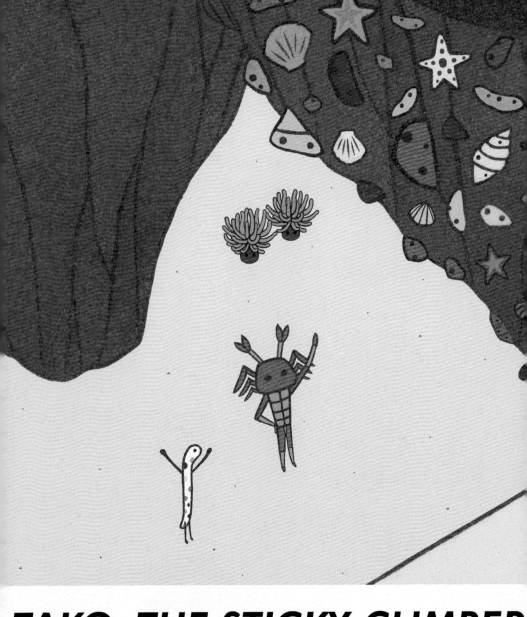

TAKO, THE STICKY CLIMBER

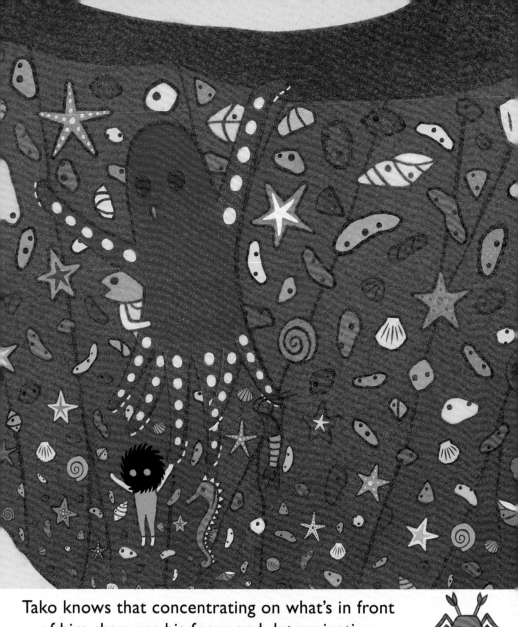

Tako knows that concentrating on what's in front
of him sharpens his focus and determination.
Tako doesn't know everyone has found an easier way up.

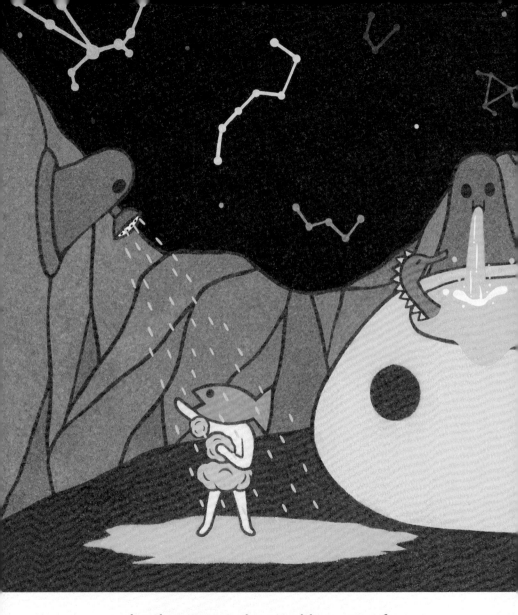

Looking up at the sparkling stars from
the bath gets me totally relaxed.

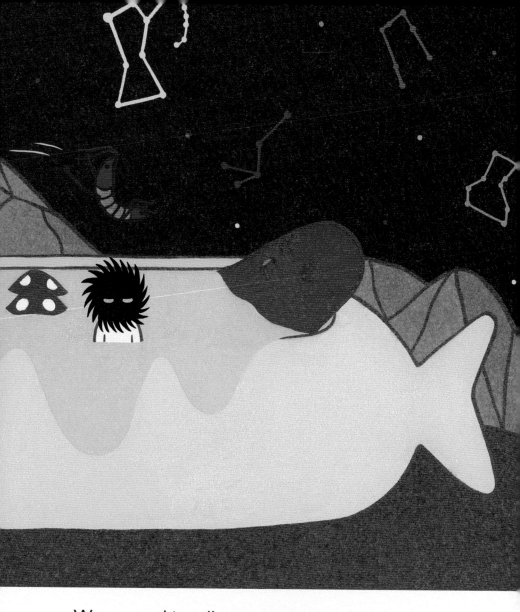

We are washing all our anxieties and worries
away to enjoy a brand new day.

AT THE MUSEUM

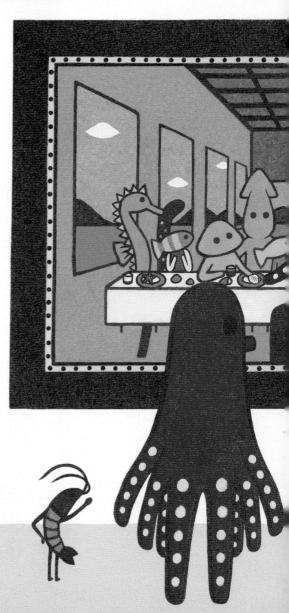

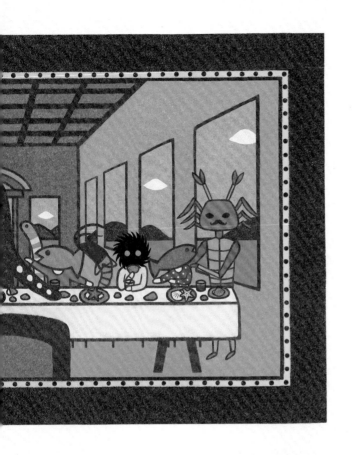

I got a lot of inspiration from
those awesome masterpieces.

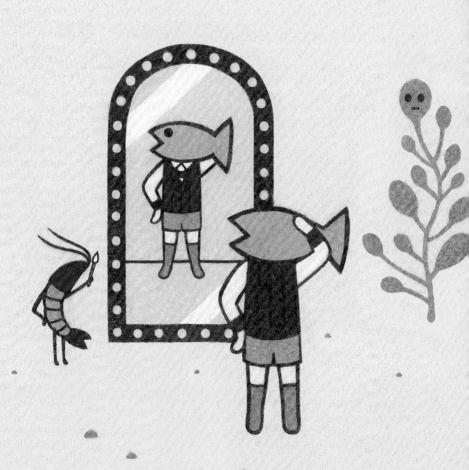

Let's dive into my inner world!

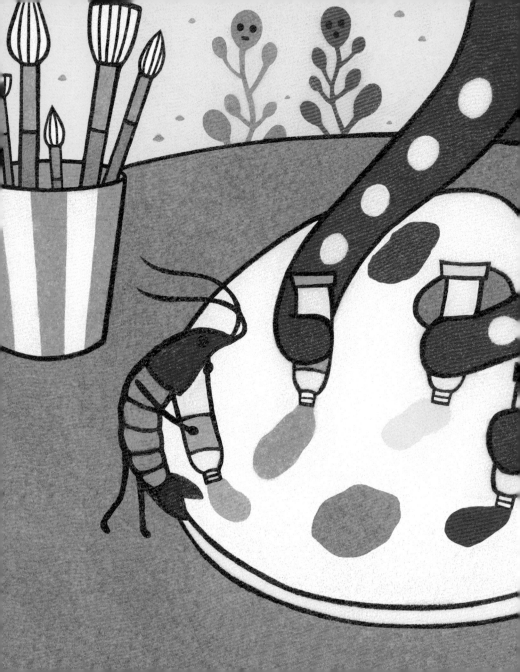

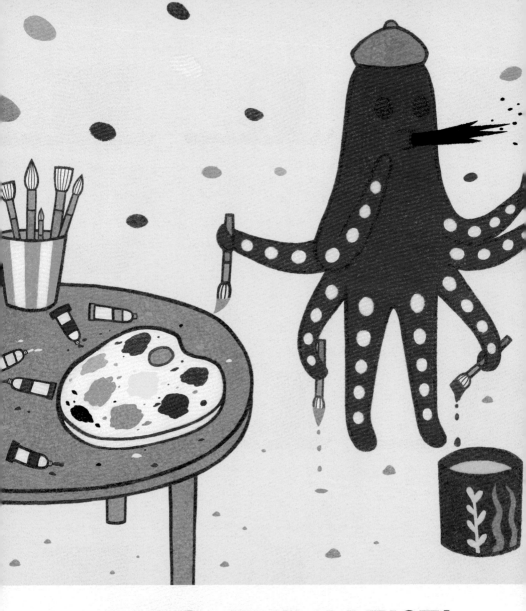

TAKO, THE ARTIST!

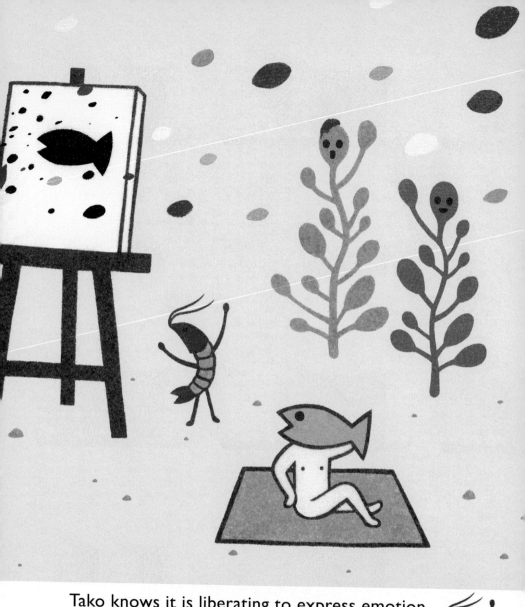

Tako knows it is liberating to express emotion
and sensation as they are.
But Tako doesn't know he's dripping paint everywhere.

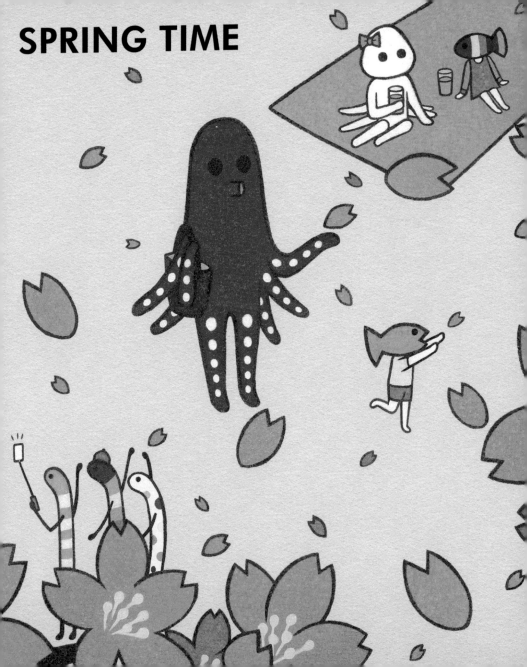

SPRING TIME

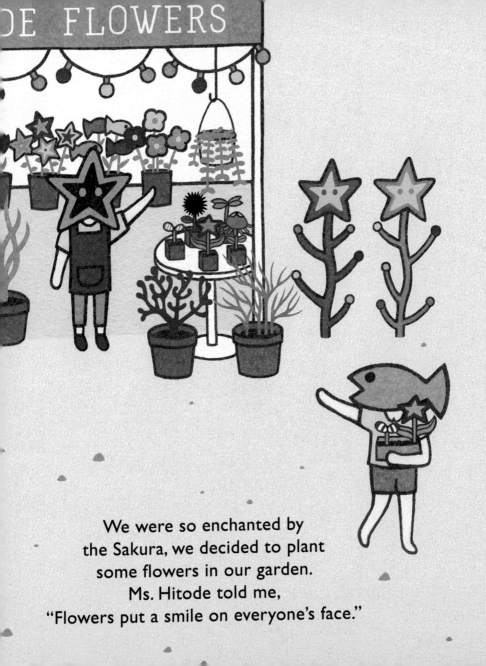

We were so enchanted by
the Sakura, we decided to plant
some flowers in our garden.
Ms. Hitode told me,
"Flowers put a smile on everyone's face."

Let's see how they turn out.

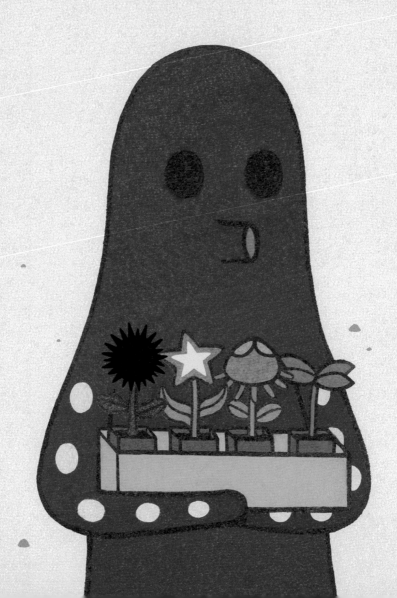

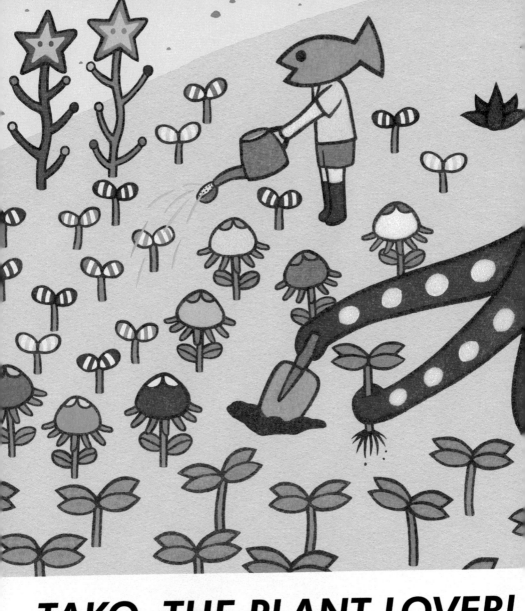

TAKO, THE PLANT LOVER!

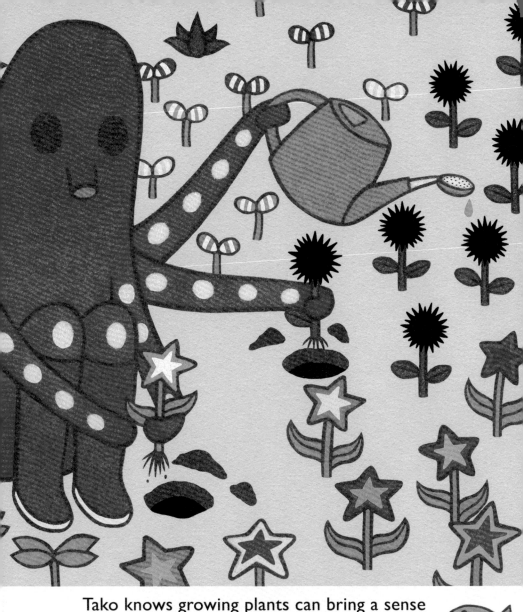

Tako knows growing plants can bring a sense
of peace and soothe the soul.
But Tako doesn't know his watering can is empty.

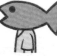

Unique and colorful flowers in full bloom!

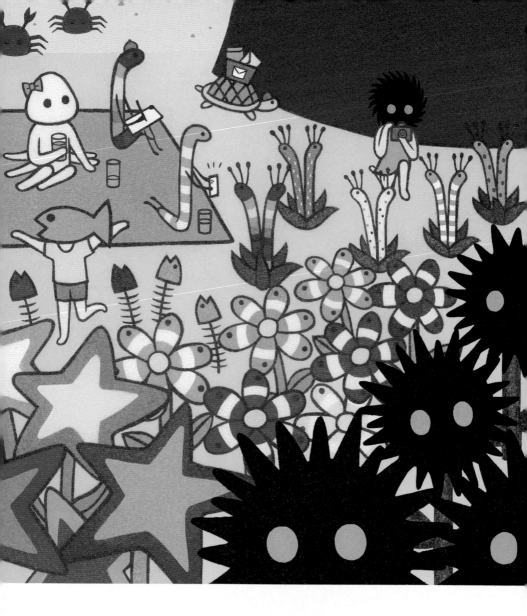

It's true, everyone's smiling.

VACATION MODE: ON

MON	TUE	WED	
			1
5	6	7	(8)
12	13	14	15
19	20	21	22
26	27	28	29

7

	FRI	SAT	SUN
	2	3	4
	⑨	⑩	⑪

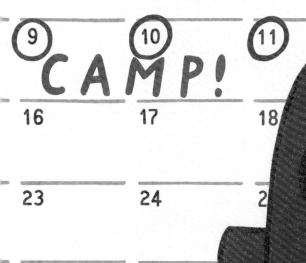

CAMP!

	16	17	18
	23	24	2
	30	31	

Time to go hiking and camping with my fabulous friends.

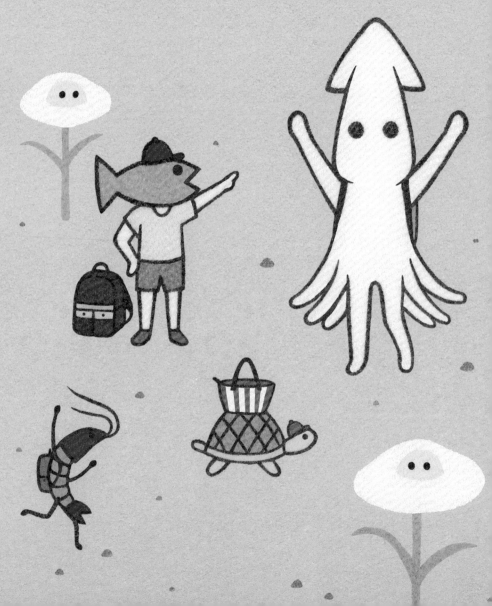

Let's spend some time in nature to refresh!

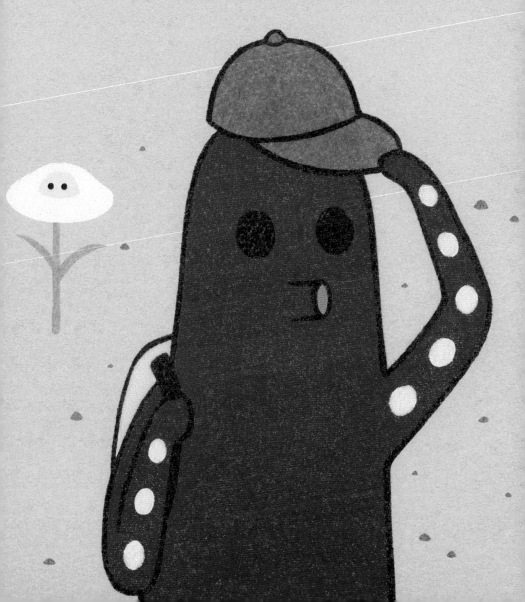

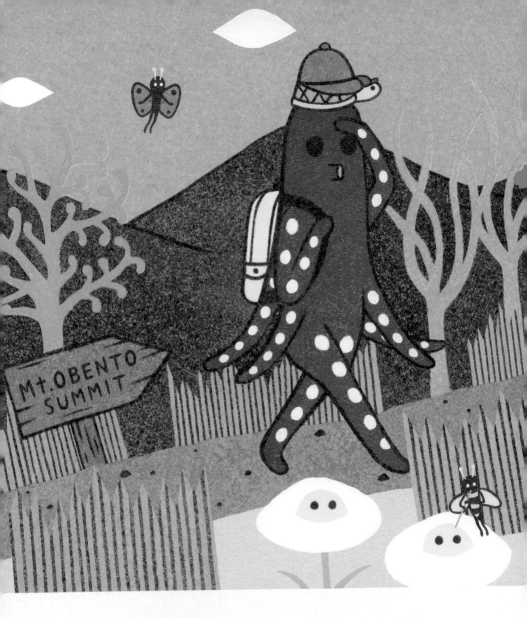

We'll each go at our own pace up Mt. Obento.

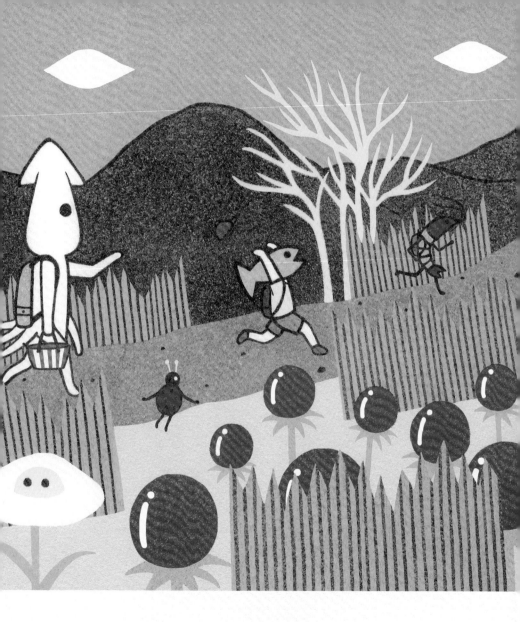

Hello, my little new friends!

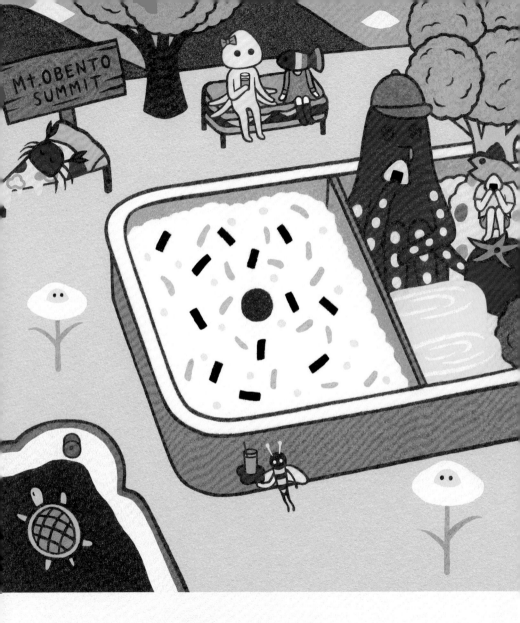

Everything tastes a better when we eat together outdoors!

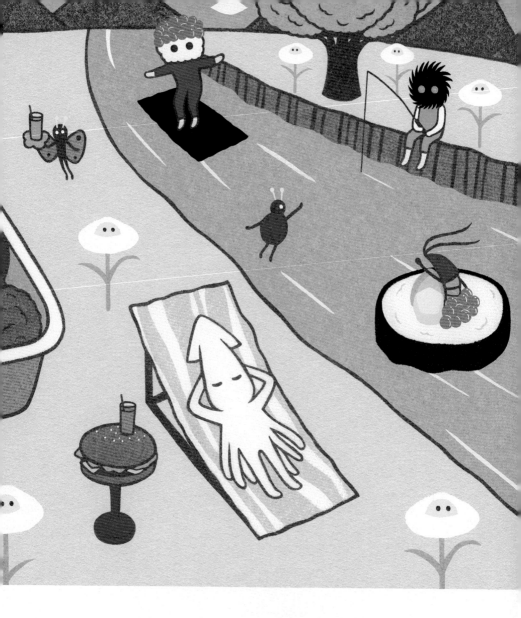

It's because of the fresh air!

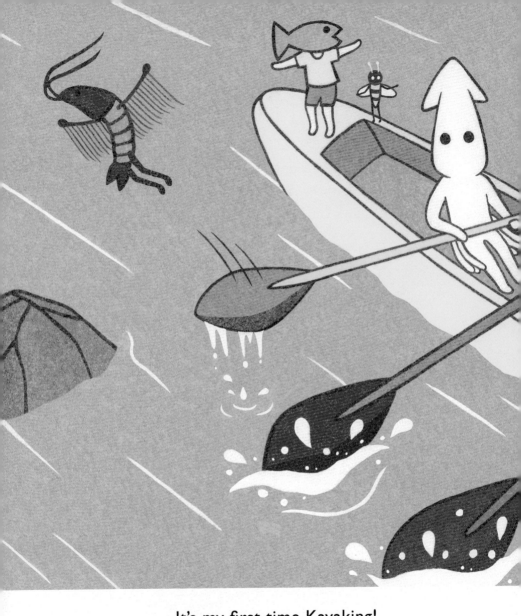

It's my first time Kayaking!
We paddle in sync to move forward.

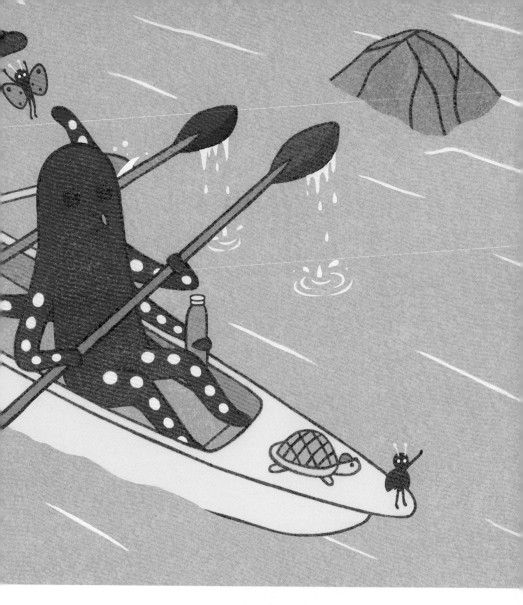

"Don't be afraid to try new things!"
I love Ebi's motto.

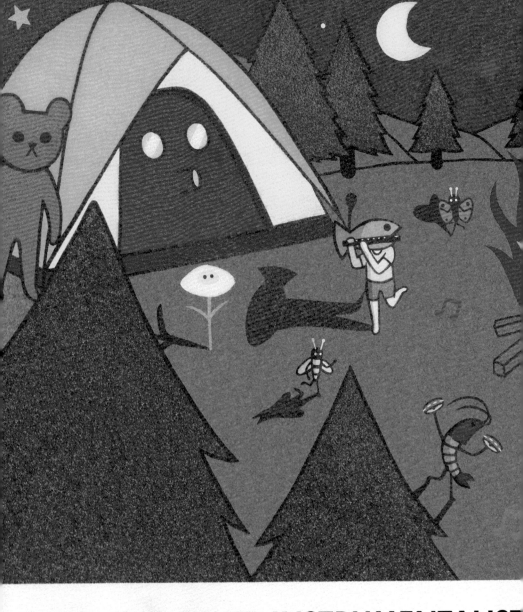

TAKO, THE MULTI-INSTRUMENTALIST

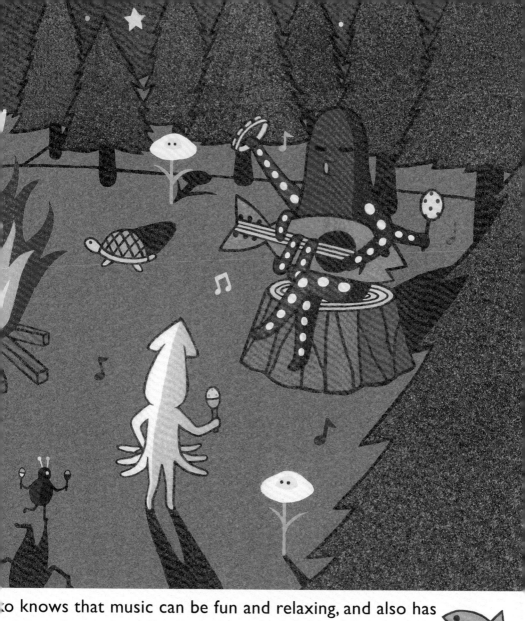

knows that music can be fun and relaxing, and also has magical power to focus moments and create memories. Tako doesn't know that Kuma is peeking over at them.

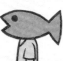

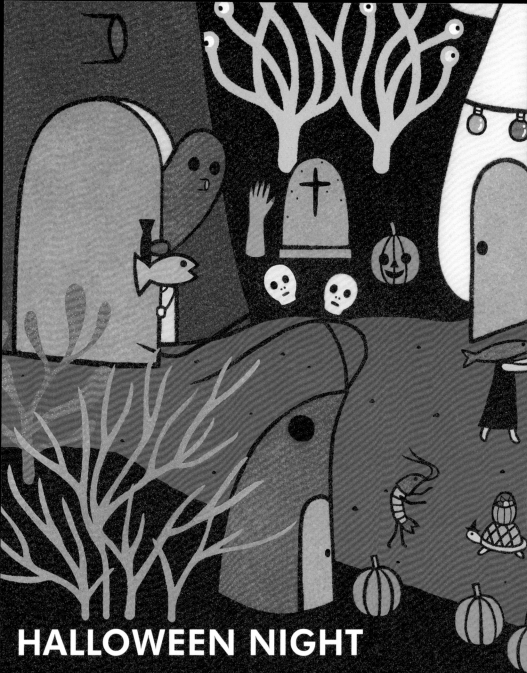

HALLOWEEN NIGHT

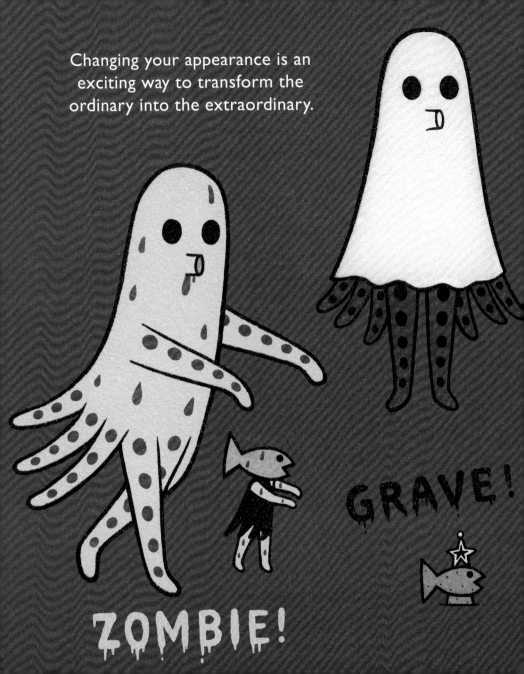

Changing your appearance is an exciting way to transform the ordinary into the extraordinary.

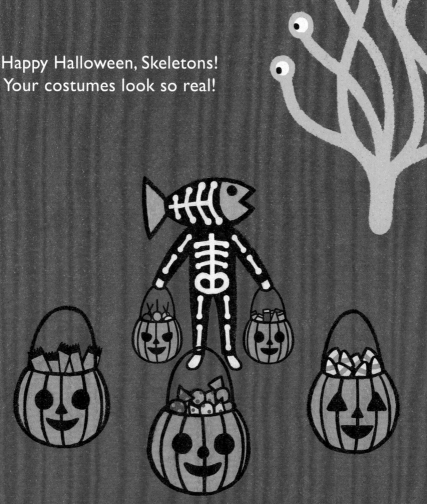

Happy Halloween, Skeletons!
Your costumes look so real!

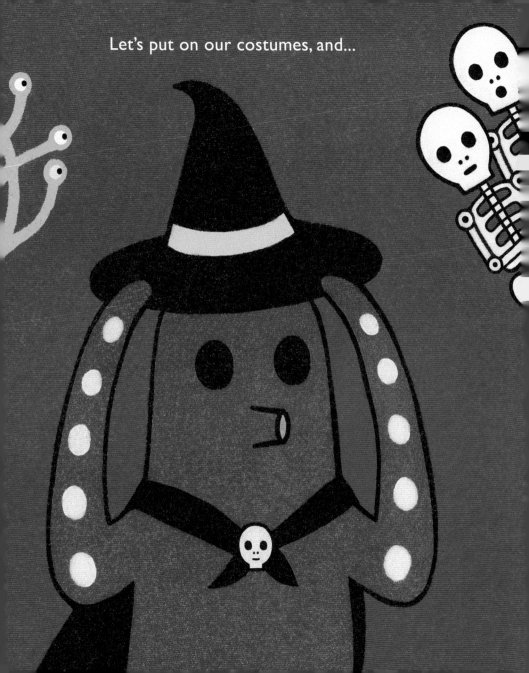

Let's put on our costumes, and...

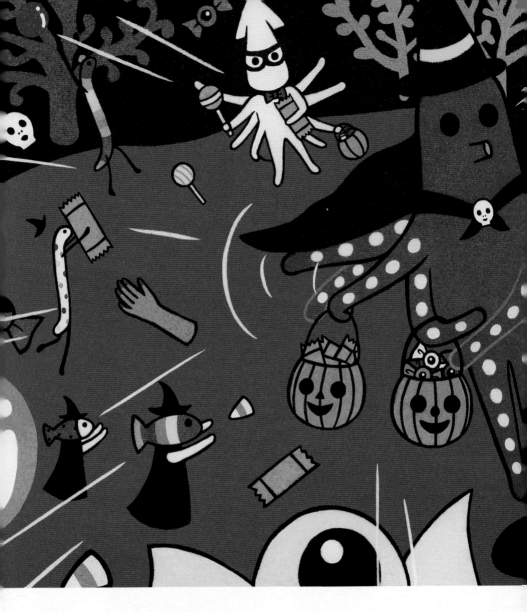

TAKO, THE SPINNING CANDY DISPENSER

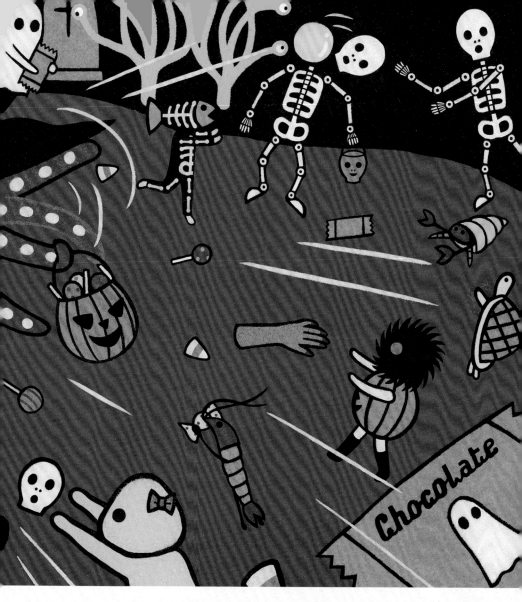

Tako knows when everyone is happy, he's happy too.
But Tako doesn't know Skeleton's head flew off.

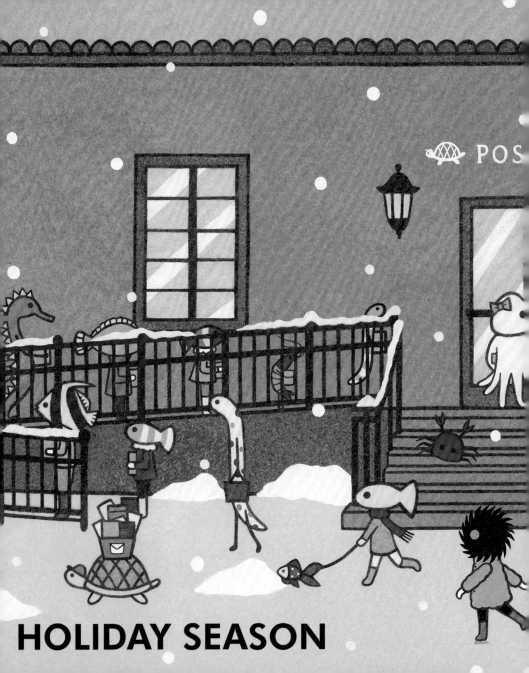

POS

HOLIDAY SEASON

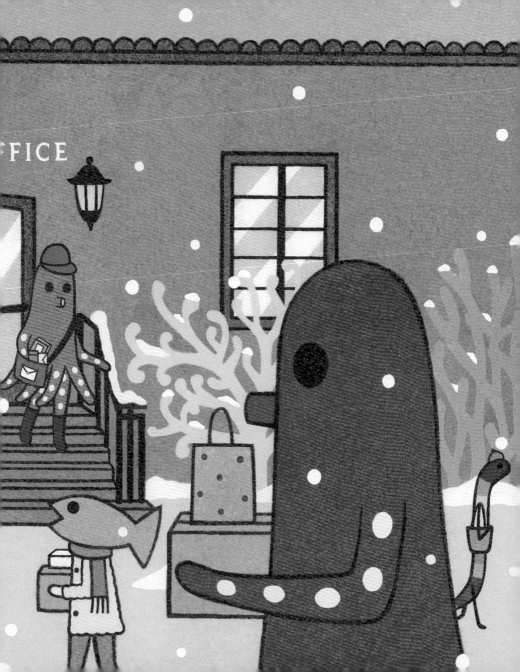

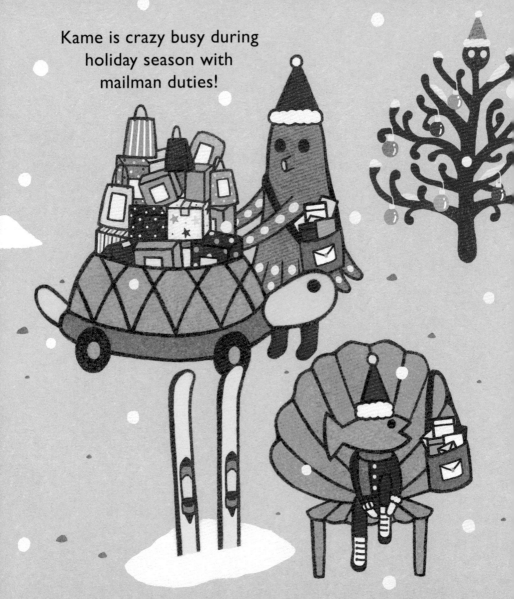

Kame is crazy busy during holiday season with mailman duties!

We'll help deliver a bunch of gifts with love.

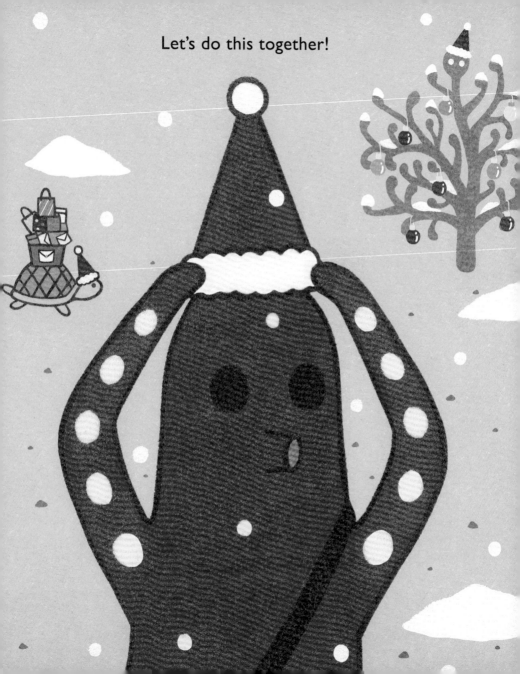

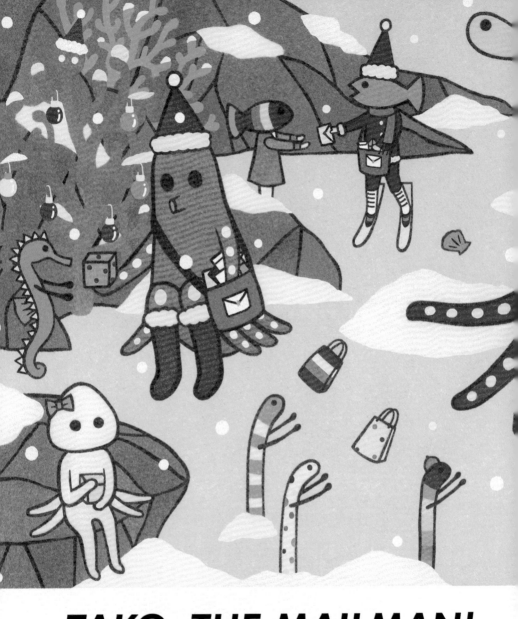

TAKO, THE MAILMAN!

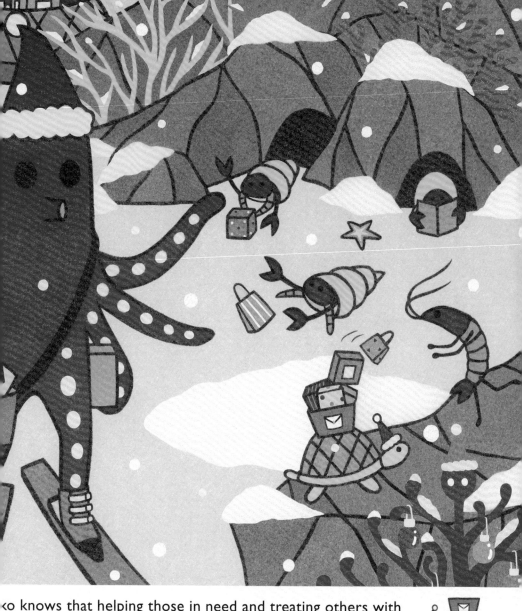

ko knows that helping those in need and treating others with
nsideration will create a chain reaction of joy and kindness.
Tako doesn't know sneaky Sakana has delivered a love letter.

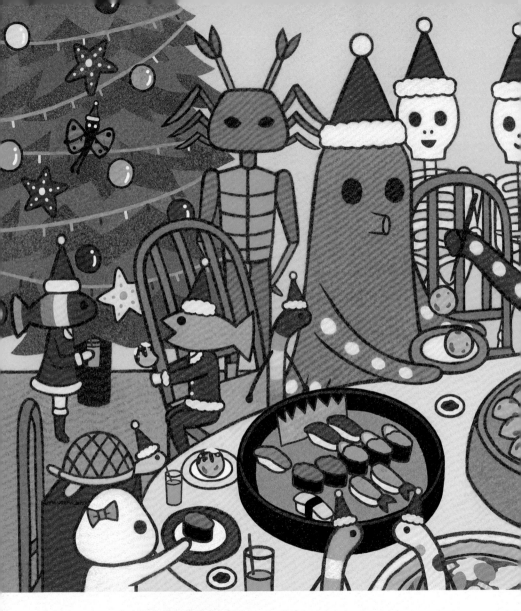

A successful delivery done, it's time for a
Christmas party with my merry band of friends!

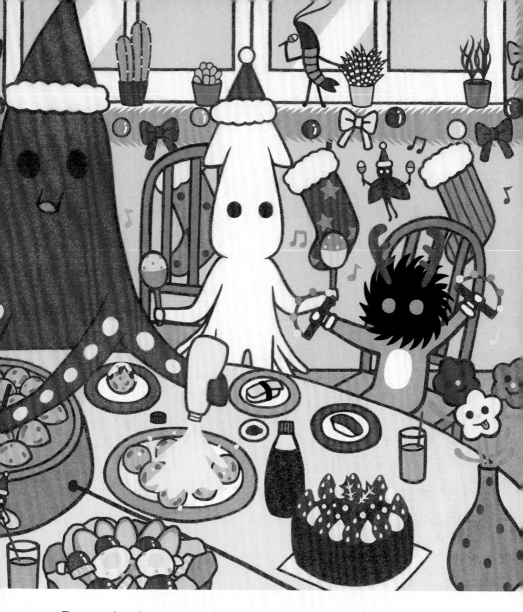

From the bottom of my heart, thank you all for
making this a wonderful and meaningful year.

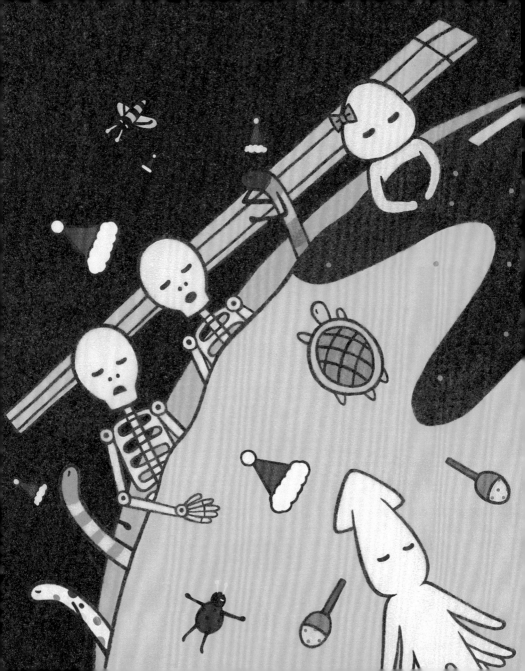

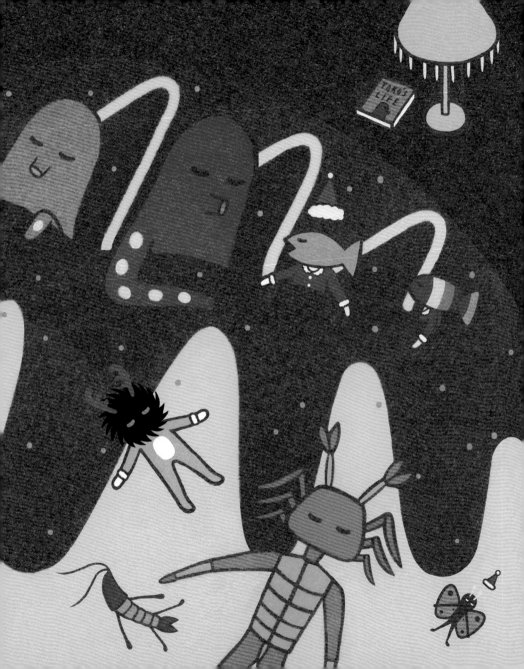

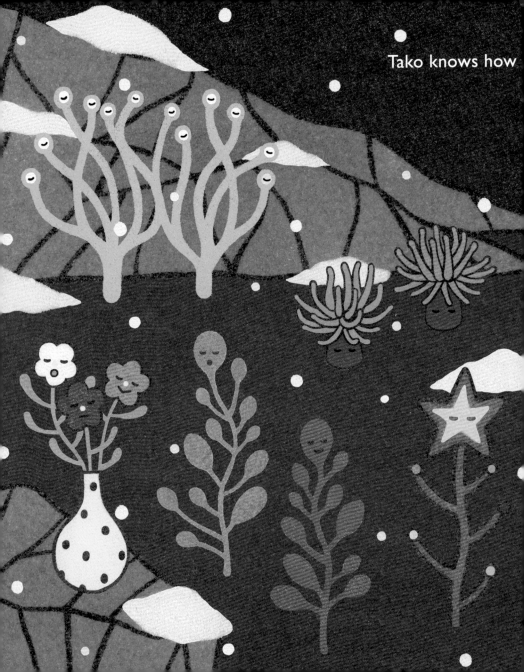

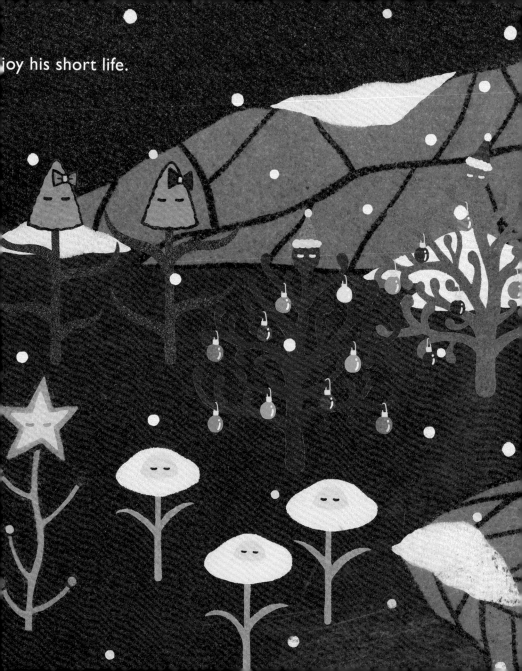

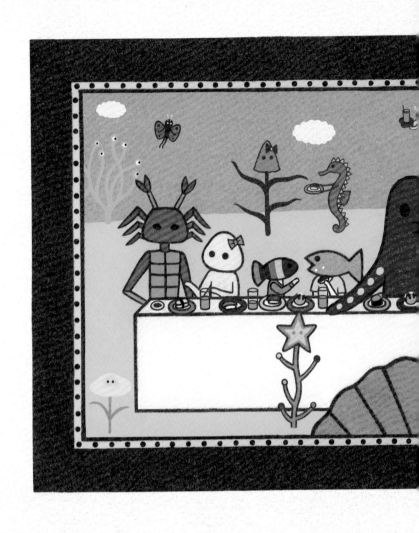

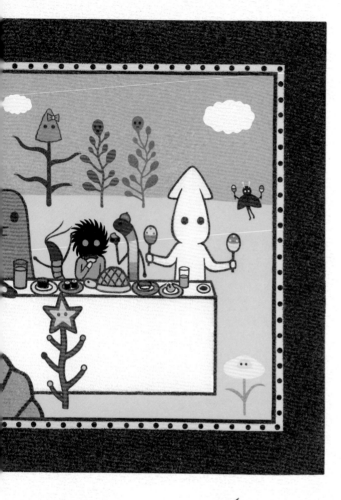

SEARCH & FIND

The residents of Tako City

Mr. Personality:
Sakana

Thoughtful and Kind:
Ika

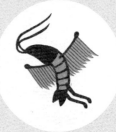

Lover of Life:
Ebi

Slow and Steady:
Kame

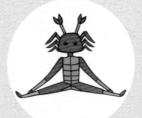

Macho Man:
Kani

Multi-hobbyist:
Uni

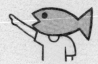

Can you find all the characters?

Artist Friend:
Chin-anago

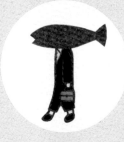

Diligent and Studious:
Sanma

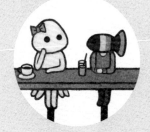

BFFs:
Kurage & Ayu

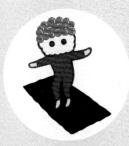

Seaweed Surfer:
Ikura

Traffic Lights:
Hotate Sisters

Precious Book:
TAKO'S LIFE

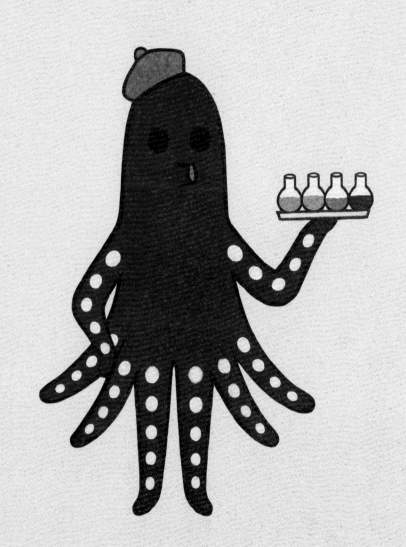

ABOUT THE AUTHOR

Naoshi is a Japanese SUNAE (sand art) artist based in Los Angeles.

She began drawing "TAKO" (Japanese for octopus) in 2013. Fascinated by their rounded form and blank expression, she started wondering how they spent their days with their eight arms and legs. They must be able to do so much at once! The more she thought about them, the more she became immersed in the world of Tako.

After learning that Octopus' life span can be as short as one to two years (*depending on the species), she was struck by their strength to live out their lives in earnest, despite their fate. She was reminded that "time," which had seemed infinite, is in fact very precious. "TAKO KNOWS" reflects her desire to cherish and enjoy the present moment to the fullest!

She hopes that anyone who reads this book is able to spend their days filled with joy and humor, just like Tako! Tako knows that your life is filled with brightness!

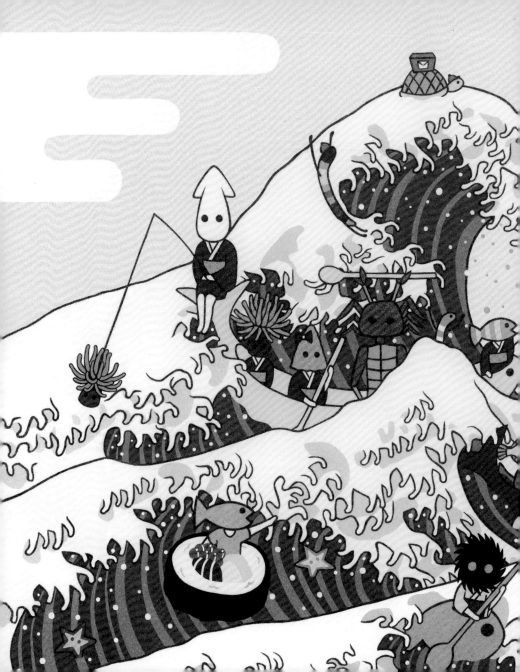

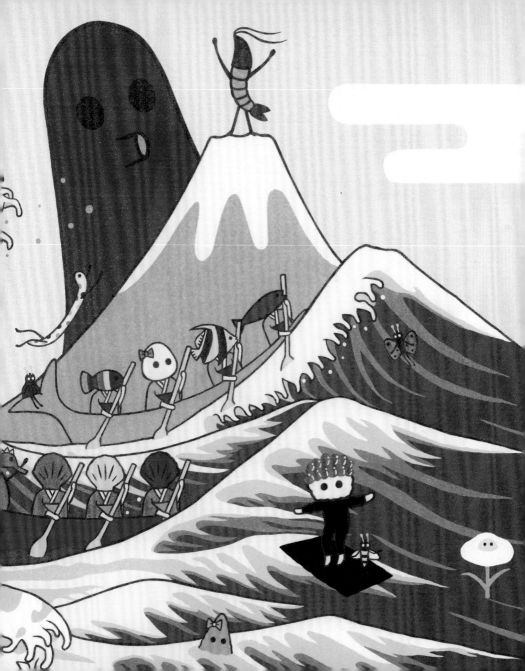

ISBN: 979-8-9856527-4-1

Library of Congress Control Number: On File

Printed in China

Overcup Press

Overcupbooks.com

4207 SE Woodstock Blvd. #253

Portland, OR 97206

Nao-shi.com

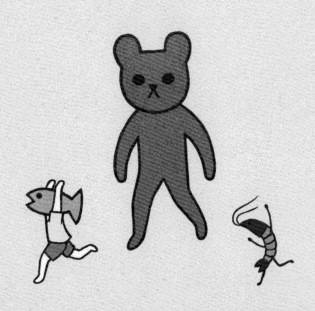

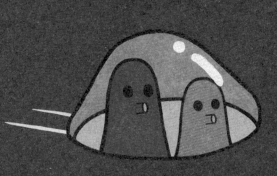